To Jeannie
From Nadine
Mery Christmas 1994

The Best
— *of* —
Friends

THOUGHTS ON FRIENDSHIP

THIS BOOK BELONGS TO

Jeannie SantySusso

The Best
of
Friends

THOUGHTS ON FRIENDSHIP

Edited by Kevin Osborn

Ariel Books

Andrews and McMeel
Kansas City

ISBN: 0-8362-4724-8

Library of Congress Catalog Card Number: 94-71132

Contents

Introduction

The world's best writers, philosophers, and artists have speculated on, thought about, and depicted friendships for hundreds of years. Most of us don't usually have the time to ponder our friendships, but we certainly know they are there. Our friends inspire, provoke, challenge, and support us as we share the experiences of life.

The greatest pleasures of life gratify us even more when we share them with friends. When we watch a movie that touches or entertains us, when we enjoy fabulous food in an out-of-the-way restaurant, when we hear a terrific song on the radio, or first encounter a favorite author, do we keep it to ourselves? Of course not. We offer such experiences to our friends, trusting that they, too, will take pleasure in the things that we enjoy.

While we relish the good times we share with

our friends, we cherish them all the more when they stick with us through our sadness or disappointment. Hard times truly test the quality of a friendship. When a family member dies, when job prospects look dim, when a crying infant strips us of sleep and civility, we turn to our dearest friends for comfort and support. Often, we don't even need to turn to them, for they have already come to us. Simply by listening, by being there for us, our friends ease our pain. Friendship fortunately offers many opportunities to return the favor. And in lifting up our friends' spirits when their troubles weigh them down, we are equally rewarded.

The Best of Friends

Memories of childhood friends are with us always: friends with whom we invented secret languages, known only to us; friends who encouraged us in our awkward attempts to ask someone out on a first date. We forgive and forget the occasional acts of thoughtlessness that occur in childhood friendships.

Instead, we recall laughing for hours on end with a special friend (though we may not remember why). We remember the comingled tears that eased each other's grief. We carry with us memories of painful separations—and joyous reunions.

We are slower to make friends in adulthood, choosing with care the people with whom we will develop deeply intimate relationships. But once we have found a friend, we make every effort to nurture and strengthen the relationship. For although adult friendships can be as noisy and turbulent as childhood ones, they offer the possibility of greater quietness and serenity. In adult life, words become less necessary to sustain a friendship; shared silence can be as rewarding as shared conversation.

Who makes a better friend—an old friend or a new one? This debate has raged for centuries, and everybody has an opinion. Each kind of friendship has its own unique gifts. New friends, like new loves, intoxicate with startling discoveries. Every experience, every opinion, every memory shared becomes a revelation. Friendships that survive the test of time, however, offer a sense of trust, loyalty, dependability, and comfort.

A similar debate revolves around the question of gender. Does a man or a woman offer greater friendship? Friendships with people of the same sex offer a special sense of common experience, kinship, and understanding. Yet friendships with people of the opposite sex broaden our horizons, deepen our appreciation of differences, and prove to us that understanding and support transcend gender.

In the end, it matters little if your friend is a man or a woman, old or new. What matters is the love that binds you together and the precious moments you are blessed to share. This is the true essence of friendship.

Precious Friendship

If I don't have friends, then I ain't got nothin'.
—Billie Holiday

Life becomes useless and insipid when we have no longer either friends or enemies.
—Queen Christina of Sweden

The person who tries to live alone will not succeed as a human being. His heart withers if it does not answer another heart. His mind shrinks away if he hears only the echoes of his own thoughts and finds no other inspiration.
—Pearl S. Buck

You meet your friend, your face brightens–you have struck gold.

–Kassia

No person is your friend who demands your silence, or denies your right to grow.

–Alice Walker

Friendship is the gift of the gods, and the most precious boon to man.

–Benjamin Disraeli

The most I can do for my friend is simply to be his friend. I have no wealth to bestow on him. If he knows that I am happy in loving him, he will want no other reward. Is not friendship divine in this?

–Henry David Thoreau

You ought not to have or to love a friend for what he will give you. . . . A friend should be loved freely for himself, and not for anything else.

–Saint Augustine

Friendship consists in forgetting what one gives and remembering what one receives.

> –Alexandre Dumas

But friendship is precious, not only in the shade, but in the sunshine of life; and thanks to a benevolent arrangement of things, the greater part of life is sunshine.

> –Thomas Jefferson

Friendship is unnecessary, like philosophy, like art. . . . It has no survival value; rather it is one of those things that give value to survival.

> –C. S. Lewis

If I had to choose between betraying my country and betraying my friend, I hope I should have the guts to betray my country.

> –E. M. Forster

Making Friends

Treat your friends as you do your pictures, and place them in their best light.

–Jennie Jerome Churchill

He who expects his friend not to be annoyed at his wens will excuse the other's warts. It is only fair that one who asks indulgence for shortcomings should give it in return.

–Horace

Intimacies between women often go backwards, beginning in revelations and ending up in small talk without loss of esteem.

–Elizabeth Bowen

By secrecy I mean you both want the habit of telling each other at the moment everything that happens–where you go–and what you do–that free communication of letters and opinions, just as they arise . . . which is after all the only groundwork of friendship. . . .

–Mary Ann Lamb

We cannot tell the precise moment when friendship is formed. As in filling a vessel drop by drop, there is at last a drop which makes it run over; so in a series of kindnesses there is at last one which makes the heart run over.

–Samuel Johnson

The best things in life are never rationed. Friendship, loyalty, love do not require coupons.

–George T. Hewitt

After an acquaintance of ten minutes many women will exchange confidences that a man would not reveal to a lifelong friend.

–Page Smith

It is a mistake to think that one makes a friend because of his or her qualities; it has nothing to do with qualities at all. It is the person that we want, not what he does or says, or does not do or say, but what he *is* that is eternally enough!

–Arthur Christopher Benson

The problems that plague a friendship are rarely one hundred percent the other person's fault. We should self-examine carefully before we make up our mind–and before we close it.

–Judith Viorst

An Honest Friend

A friend can tell you things you don't want to tell yourself.

–Frances Ward Wheeler

My true friends have always given me that supreme proof of devotion, a spontaneous aversion for the man I loved.

–Colette

We are all travellers in the wilderness of this world, and the best that we find in our travels is an honest friend.

–Robert Louis Stevenson

If we were all given by magic the power to read each other's thoughts, I suppose the first effect would be to dissolve all friendships.

–Bertrand Russell

It's important to our friends to believe that we are unreservedly frank with them, and important to friendship that we are not.

–Mignon McLaughlin

You said just the thing that I wished you to say, And you made me believe that you meant it. . . .

–Grace Stricker Dawson

To find a friend one must close one eye–To keep him two.

–Norman Douglas

One of the most beautiful qualities of true friendship is to understand and be understood.

–Seneca

I look upon my friend as "the beautiful enemy" who alone is able to offer me total candor. Friendship is by its very nature freer of deceit than any other relationship we can know because it is the bond least affected by striving for power, physical pleasure, or material profit, most liberated from any oath of duty or of constancy.

–Francine du Plessix Gray

What I cannot love, I overlook. Is that real friendship?

–Anaïs Nin

Solace and Support

Two people holding each other up like flying buttresses. Two people depending on each other and babying each other and defending each other against the world outside.

–Erica Jong

Friendship cheers like a sunbeam; charms like a good story; inspires like a brave leader; binds like a golden chain; guides like a heavenly vision.

–Newell D. Hillis

Best friend, my well-spring in the wilderness!

–George Eliot

Your friend is your needs answered.
He is your field which you sow with love and
　　reap with thanksgiving.
And he is your board and your fireside.
For you come to him with your hunger, and
　　you seek him for peace.
<div align="right">–Kahlil Gibran</div>

Perfect tranquillity of life . . . is nowhere to be
found but in retreat, a faithful friend, and a good
library. . . .
<div align="right">–Aphra Behn</div>

The glory of friendship is not the outstretched
hand, nor the kindly smile, nor the joy of com-
panionship; it is the spiritual inspiration that
comes to one when he discovers that someone
else believes in him and is willing to trust him
with his friendship.
<div align="right">–Ralph Waldo Emerson</div>

Friendship is a sheltering tree.
<div align="right">–Samuel Taylor Coleridge</div>

Friendship, a dear balm. . . .
A smile among dark frowns: a beloved light:
A solitude, a refuge, a delight.

–Percy Bysshe Shelley

If the while I think on thee, dear friend,
All losses are restored, and sorrows end.

–William Shakespeare

Friendship adds a brighter radiance to prosperity
and lightens the burden of adversity by dividing
and sharing it.

–Cardinal Richelieu

The test of friendship is assistance in adversity,
and that, too, unconditional assistance.

–Mohandas K. Gandhi

Love Refined

Friendship is every bit as sacred and eternal as marriage.

—Katherine Mansfield

Friendship's a noble name, 'tis love refined.

—Susannah Centlivre

The verb "to love" in Persian is "to have a friend." "I love you" translated literally is "I have you as a friend," and "I don't like you" simply means "I don't have you as a friend."

—Shusha Guppy

However rare true love may be, it is less so than friendship.

–François de La Rochefoucauld

I would be friends with you and have your love.

–William Shakespeare

Love demands infinitely less than friendship.

–George Jean Nathan

His Majesty is my best friend, the one person to whom I can say just about anything.

–Queen Noor el-Hussein

There is an important difference between love and friendship. While the former delights in extremes and opposites, the latter demands equality.

–Françoise d'Aubigné Maintenon

Sharing Moments

I want someone to laugh with me, someone to
be grave with me, someone to please me and
help my discrimination with his or her own
remark, and at times, no doubt, to admire my
acuteness and penetration.

—Robert Burns

The steady and merciless increase of occupations,
the augmented speed at which we are always
trying to live, the crowding of each day with
more work than it can profitably hold . . . has
cost us, among other good things, the undis-
turbed enjoyment of friends. Friendship takes
time, and we have no time to give it.

—Agnes Repplier

There's a kind of emotional exploration you plumb with a friend that you don't really do with your family.

—Bette Midler

No good thing is pleasant to possess, without friends to share it.

—Seneca

In the hour of distress and misery the eye of every mortal turns to friendship; in the hour of gladness and conviviality, what is our want? It is friendship. When the heart overflows with gratitude, or with any other sweet and sacred sentiment, what is the word to which it would give utterance? A friend.

—Walter Savage Landor

There was a definite process by which one made people into friends, and it involved talking to them and listening to them for hours at a time.

—Rebecca West

Friends and Equals

Oh, the comfort, the inexpressible comfort, of feeling safe with a person, having neither to weigh thoughts nor measure words, but to pour them all out just as they are, chaff and grain together, knowing that a faithful hand will take and sift them, keep what is worth keeping, and then, with the breath of kindness, blow the rest away.

–George Eliot

You cannot be friends upon any other terms than upon the terms of equality.

–Woodrow Wilson

Nothing so fortifies a friendship as a belief on the part of one friend that he is superior to the other.

–Honoré de Balzac

There should be no inferiors and no superiors for true world friendship.

–Carlos P. Romulo

It is well, when one is judging a friend, to remember that he is judging you with the same godlike and superior impartiality.

–Arnold Bennett

Old Friends and New

The companions of our childhood always possess a certain power over our minds which hardly any later friend can obtain.

–Mary Shelley

Happy is he to whom, in the maturer season of life, there remains one tried and constant friend. . . .

–Anna Letitia Barbauld

As old wood is best to burn, old horse to ride, old books to read, and old wine to drink, so are old friends always most trusty to use.

–Leonard Wright

Yes'm, old friends is always best, 'less you can catch a new one that's fit to make an old one out of.

–Sarah Orne Jewett

She found to her surprise that an old friend is not always the person whom it is easiest to make a confidant of: there was the barrier of remembered communication under other circumstances–there was the dislike of being pitied and informed by one who had been long wont to allow her the superiority.

–George Eliot

We should not let the grass grow on the path of friendship.

–Marie-Thérèse Rodet Geoffrin

It is great to have friends when one is young, but indeed it is still more so when you are getting old. When we are young, friends are, like everything else, a matter of course. In the old days we know what it means to have them.

–Edvard Grieg

Friendships
in Film

Jessica Tandy and Morgan Freeman in
Driving Miss Daisy

Geena Davis and Susan Sarandon in
Thelma & Louise

E.T. and Henry Thomas in
E.T.–The Extra-Terrestrial

Jack Lemmon and Walter Matthau in
The Odd Couple
and
Grumpy Old Men

Paul Newman and Robert Redford in
Butch Cassidy and the Sundance Kid

Donald Sutherland and Elliott Gould in
*M*A*S*H*

Jon Voight and Dustin Hoffman in
Midnight Cowboy

River Phoenix and Wil Wheaton in
Stand By Me

Daniel Stern, Bruno Kirby, and Billy Crystal in
City Slickers

Vanessa Redgrave and Jane Fonda in
Julia

Noriyuki "Pat" Morita and Ralph Macchio in
The Karate Kid

James Stewart and John Wayne in
The Man Who Shot Liberty Valance

Isabelle Huppert and Miou-Miou in
Entre Nous

Margaret Avery and Whoopi Goldberg in
The Color Purple

Sean Penn and Nicolas Cage in
Racing with the Moon

A Mirror of Self

Each friend represents a world in us, a world possibly not born until they arrive, and it is only by this meeting that a new world is born.

—Anaïs Nin

The best mirror is an old friend.

—George Herbert

One recipe for friendship is the right mixture of commonality and difference. You've got to have enough in common so that you understand each other and enough difference so that there is something to exchange.

—Robert Weiss

So closely interwoven have been our lives, our purposes, and experiences that, separated, we have a feeling of incompleteness–united, such strength of self-assertion that no ordinary obstacles, differences, or dangers ever appear to us insurmountable.

–Elizabeth Cady Stanton

One friend in a lifetime is much; two are many; three are hardly possible. Friendship needs a certain parallelism of life, a community of thought, a rivalry of aim.

–Henry Brooks Adams

If I knew you and you knew me,
As each one knows his own self, we
Could look each other in the face
And see therein a truer grace.

–Nixon Waterman

In my friend, I find a second self.

–Isabel Norton

We learn our virtues from the friends who love us; our faults from the enemy who hates us. We cannot easily discover our real character from a friend. He is a mirror, on which the warmth of our breath impedes the clearness of the reflection.

–Jean Paul Richter

My fellow, my companion, held most dear,
My soul, my other self, my inward friend.

–Mary Sidney Herbert

Friendship is one heart in two bodies.

–Joseph Zabara

Friendship is simply loving agreement in all life's questions.

–Cicero

It is my melancholy fate to like so many people I profoundly disagree with and often heartily dislike people who agree with me.

–Mary Kingsley

Eloquent Silence

I trust that even when I'm out of sight I'm not out of mind. Silences and distances are woven into the texture of every true friendship.

–Roberta Israeloff

True friendship comes when silence between two people is comfortable.

–Dave Tyson Gentry

The true test of friendship is to be able to sit or walk with a friend for an hour in perfect silence without wearying of one another's company.

–Dinah Maria Mulock Craik

Bringing Out the Best

Peace is achieved one person at a time, through a series of friendships.
> –Fatma Reda

Who knows the joys of friendship,
The trust, security, and mutual tenderness,
The double joys, where each is glad for both.
> –Nicholas Rowe

The holy passion of Friendship is of so sweet and steady and loyal and enduring a nature that it will last through a whole lifetime, if not asked to lend money.
> –Mark Twain

Friends should consider themselves as the sacred guardians of each other's virtue; and the noblest testimony they can give of their affection is the correction of the faults of those they love.

–Anna Letitia Barbauld

I am speaking now of the highest duty we owe our friends, the noblest, the most sacred–that of keeping their own nobleness, goodness, pure and incorrupt. . . . If we *let* our friend become cold and selfish and exacting without a remonstrance, we are no true love, no true friend.

–Harriet Beecher Stowe

Friendship is an education. It draws the friend out of himself and all that is selfish and ignoble in him and leads him to life's higher levels of altruism and sacrifice.

–G. D. Prentice

I count myself in nothing else so happy
As in a soul remembering my good friends.

–William Shakespeare

We need someone to believe in us–if we do well, we want our work commended, our faith corroborated. The individual who thinks well of you, who keeps his mind on your good qualities, and does not look for flaws, is your friend. Who is my brother? I'll tell you: he is one who recognizes the good in me.

–Elbert Hubbard

Beauty, truth, friendship, love, creation–these are the great values of life. We can't prove them, or explain them, yet they are the most stable things in our lives.

–Dr. Jesse Herman Holmes

The text of this book was set in Nofret Light
by Harry Chester Inc., New York City.

Book design by Michael Mendelsohn

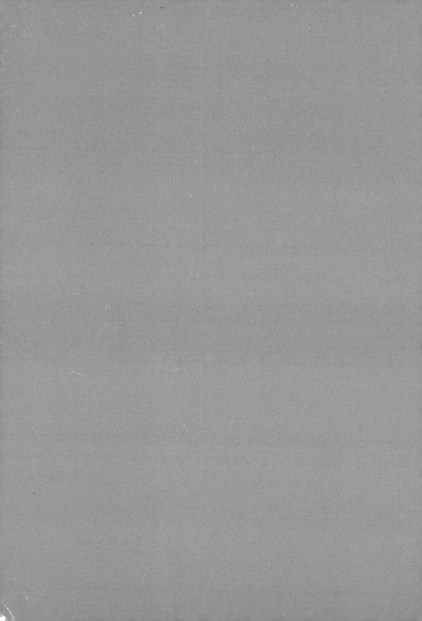